To my
Baby si[...]
friend[...] this
you like this
book. Lots in.
side remind
me of we.
Enjoy reading
it Love your
Friends

Sharon + max
come down any.
Time for a visit.
Jan. 24 202[...]

I AM GRAPEFUL

First published in Great Britain in 2019 by Pyramid,
an imprint of Octopus Publishing Group Ltd, a Hachette
UK Company.

I Am Grapeful.
Copyright © 2019 by Octopus Publishing Group Ltd.

HarperCollins books may be purchased for educational,
business, or sales promotional use. For information
please email the Special Markets Department at
SPsales@harpercollins.com.

Published in 2020 by
Harper Design
An Imprint of HarperCollins*Publishers*
195 Broadway
New York, New York 10007
Tel: (212) 207-7000
Fax: (855) 746-6023
harperdesign@harpercollins.com
www.hc.com

Distributed throughout North America by
HarperCollins Publishers
195 Broadway
New York, New York 10007

ISBN 978-0-06-299519-3
Library of Congress Control Number has been applied for.

Printed in Singapore
First Printing, 2020

I AM
GRAPEFUL

all the good thymes I want to
thank you for

TO: Tracy

FROM: Sharon/Max

HARPER
DESIGN
An Imprint of HarperCollins Publishers

THANK YOU FOR
BEAN SO GREAT

YOU GIVE ME ZEST FOR LIFE

YOU'RE MY ALL THYME
FAVORITE

Thank you

YOU ARE
TOATSAMAIZEBALLS

THANKS FOR BEING THERE
WHEN I COULD BARLEY
THINK STRAIGHT

YOU ARE THE ONE I TURNIP
TO IN THYMES OF NEED

"YOU MUST ROMAINE CALM ON YOUR JOURNEY TO GRAPENESS"

LES BROWN

YOU TAUGHT ME TO
SEIZE THE FIGGIN DAY

YOU ARE MY MOREL COMPASS

YOU'RE THE PEA'S KNEES

YOU ALWAYS
CHIA ME UP

THANKS FOR THE GOOD THYMES!

YOU TAUGHT ME TO CHERRYSH THE SIMPLE THINGS

YOU KEEP ME ON THE

STRAIGHT AND MARROW

I KNOW
YOU'D
NEVER
LEAVE ME
BEHIND
ENEMY
LIMES

THANKS FOR GETTING
ME OUT OF A PICKLE

YOU'RE THE ONION
WHO UNDERSTANDS ME

YOU WERE THERE
WHEN THE LIMES GOT BLURRED

YOU'VE ALWAYS BEAN
THERE FOR ME

THANK YOU FOR BAYLEAFING IN ME

YOU WERE THERE COME

GRAIN OR SHINE

YOU ARE
AS SALAD
AS A ROCK

THANK YOU FOR BEING SO SWEDE

YOU PUT THE YUZU
IN THANK YOU!

YOU'RE ALWAYS RAISIN MY SPIRITS

R.E.S.PEA.E.C.T.

YOU TAUGHT ME THAT A MIRACLE
IS A RAISINABLE THING TO ASK FOR

YOU ROCK.
HIGH CHIVE!

THANK YOU FOR YOUR
ENCOURAGEMINT

I COULD BARLEY BELIEVE
MY LUCK WHEN I MET YOU

THANK YOU FOR
ROMAINEING CALM

YOU'RE THE MOST RAISINABLE

HUMAN I KNOW

"THANK YOU

FOR THE MAIZE"

THE KINKS

YOU MAKE MISO
HAPPEA

THANK YOU FOR BEING
MARJORAMAZING

YOU SHOWED ME THAT ANYTHING CAN

BE FIXED WITH LOGIC AND RAISIN

THANK YOU FOR BEING A LITTLE GEM

YOU ARE
THE REAL DILL

YOU SHOWED ME EVERY
CLOUD HAS A SILVER
LIMEING

YOU TAUGHT ME NOT TO BERRY
MY HEAD IN THE SAND

YOU WERE RIGHT, GOOD THINGS

CUMIN THYME

THANK SHALLOT FOR
BEING MY FRIEND!

YOU TAUGHT
ME TO BE
GRATEFUL FOR THE
LENTIL THINGS

YOU ARE A MASTERPEAS

YOU'RE WORTH YOUR WHEAT IN GOLD

YOU KEEP ALL OF MY PEACRETS

"GOURD ONLY
KNOWS WHAT I'D
BE WITHOUT YOU"

THE BEACH BOYS

I KNOW IT'S CORNY BUT
YOU ARE AMAIZEING

YOU SHOWED ME

THAT EVERYTHING

HAPPENS FOR A RAISIN

I THINK YOU ARE A
PEARFECT LITTLE ORANGEMENT OF ATOMS

PEAS KNOW HOW GRAPEFUL I YAM

I'M MUCH MORE ME
WHEN I'M WITH YUZU

LETTUCE ALWAYS BE FRIENDS

I will be back
for visits but I
hope I can bring
Max in my new car.

YOU ARE MY FAVORITE

HUMAN BEAN

one of them

and for sure.
Max's

YOU DESERVE THE LIMELIGHT

THANK YOU FOR
YOUR SAGE ADVICE

THANKS FOR YOUR PEARL BARLEYS OF WISDOM

YOU DO A
GRAPE JOB OF
EVERYTHING

THANK YOU FOR KEEPING THE PEAS

CHIAS TO YOU!

YOU TAUGHT ME THAT LIFE IS A
JOURNEY AND ONLY I HOLD THE KIWI

YOU'RE THERE WHEN

I'M CRESSFALLEN

THANK YOU.
JUST COS

you really are
the best dog
walker for Max
He will miss you
very much

THANK YOU FOR BEING THE RAISIN I SMILE

"KNOWING YUZU NEVER WAS AN
OPTION. IT WAS A NECESSITY."

TRUTH DEVOUR

YOU ARE
BERRY SPECIAL TO ME

ENDIVE I KNOW WHAT
FRIENDSHIP IS,
IT'S BECAUSE OF YOU

(KIND OF CORNY)

YOU MAKE ME HAPPY

FROM MY HEAD

TOMATOES

I GIVE YOU PERSIMMON
TO GIVE YOURSELF A HIGH CHIVE

YOU SAY POTAYTO, I SAY POTAHTO.

THANKS FOR NOT ARGUING ABOUT IT

I APPEACHIATE EVERYTHING YOU DO FOR ME

YOU ARE
ON THE CRESST
OF EVERY WAVE

ALWAYS BEETROOT TO YOURSELF

BECAUSE THERE ARE VERY FEW PEOPLE

WHO WILL ALWAYS BEETROOT TO YOU.

(I AM ONE OF THOSE PEOPLE)

I WISH YOU
WHATEVER FLOATS
YOUR OAT

TA FOR THE PEARENTAL GUIDANCE

YOU WERE THERE TO UNLOAD

MY EMOTIONAL CABBAGE

I MINT WHAT I SAID,
YOU'RE GRAPE

THANKS FOR
BEING THE YIN
TO MY YAM

THANK YOU FOR KEEPING
ME WARM ON CHILLI NIGHTS

THERE'S NO FRIEND I'D GAUVA HAVE THAN YOU

YOU WERE THERE
WHEN IT ALL WENT
TO POT(ATO)

YOU GAVE ME
MOREL COURAGE

I MUSTARD OLD YOU A HUNDRED
THYMES HOW GRAPE YOU ARE BY NOW

I MUSTARDMIT
YOU'RE ALWAYS RIGHT

WHEN I WAS CORNFUSED
YOU SPELT IT OUT FOR ME

THANK SHALLOT

FOR EVERYTHING

"HUMOR IS RAISIN GONE MAD"

GROUCHO MARX

SENDING OLIVE MY

THANKS TO YOU

"YOU ARE THE CRESSENDO"

P. DIDDY, PUFF DADDY

For those of you who haven't herb
enough, and haven't herb-it-all-bivore,
this series has all the chiaing
things you've ever wanted to say
in vegan-friendly puns.*

Find the pearfect gift for any occasion:

AVOCUDDLE
comfort words for when you're
feeling downbeet

YOU ARE 24 CARROT GOLD
words of love for someone who's
worth their weight in root vegetables

DON'T GIVE A FIG
words of wisdom for when
life gives you lemons

*Or plant-based puns if, like us, you are no longer
sure if avocados are vegan. Or friendly.

AVOCUDDLE

comfort words for when
you're feeling downbeet

DON'T
GIVE A FIG

words of wisdom for when
life gives you lemons

DILLON AND KALE SPROUTS

YOU ARE
24 CARROT
GOLD

words of love for someone
who's worth their weight in
root vegetables

Acknowledgments and Apologies

With thanks to Andrew, Anna, Steph and Matt for their contributions, and special thanks to Joe as his contributions were really quite good.

We regret not being able to say anything nice with cavolo nero, kohlrabi, sorrel and fenugreek. We hold anyone who can in the highest regard.

"patience is bitter but its fruit is sweet"
ARISTOTLE